Simon finds a feather

Gilles Tibo

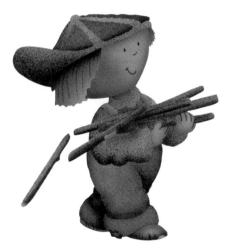

Tundra Books

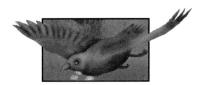

My name is Simon and I love birds.

When the days grow warm
I run outside to play with them.

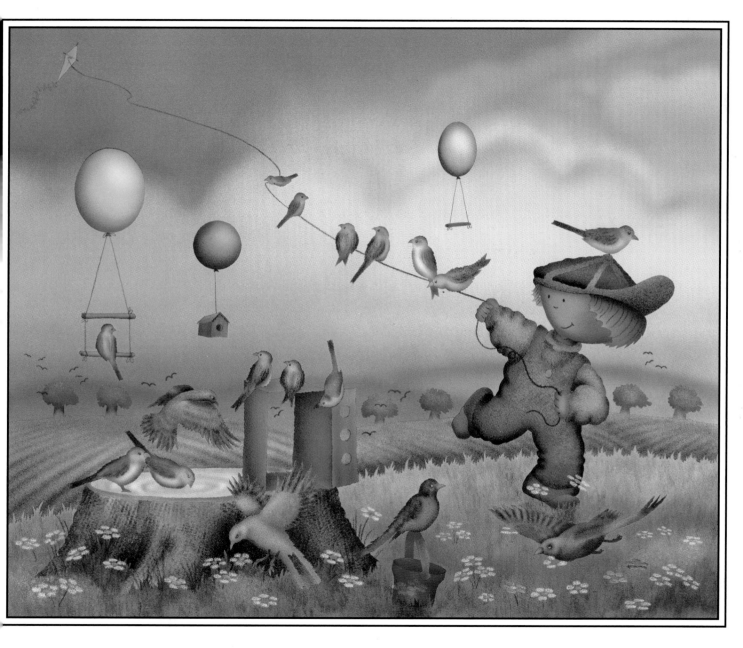

One day a red feather floats gently down.

What bird could have lost it?

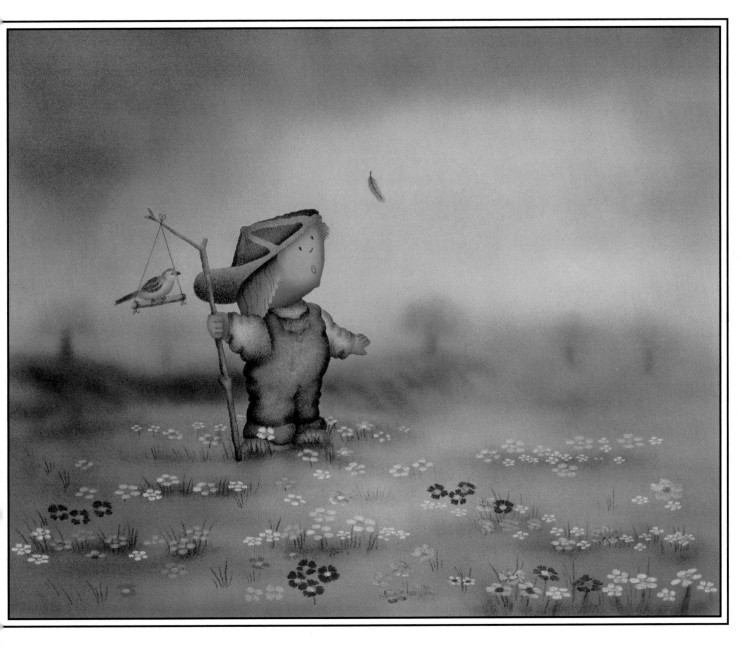

I go to the barnyard and hold out the feather.

"Not ours," says the Chicken.
"Our only reds are on top of our heads."

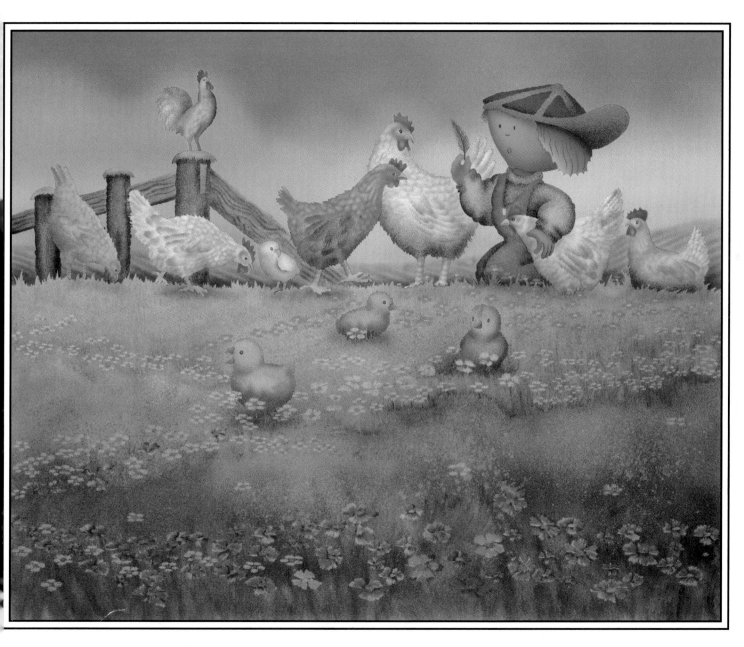

I go to the garden and talk to a Peacock.

"Not mine," says the Peacock.
He gives me a feather and shakes his blue head.
"Mine have all colors, but not one is so red."

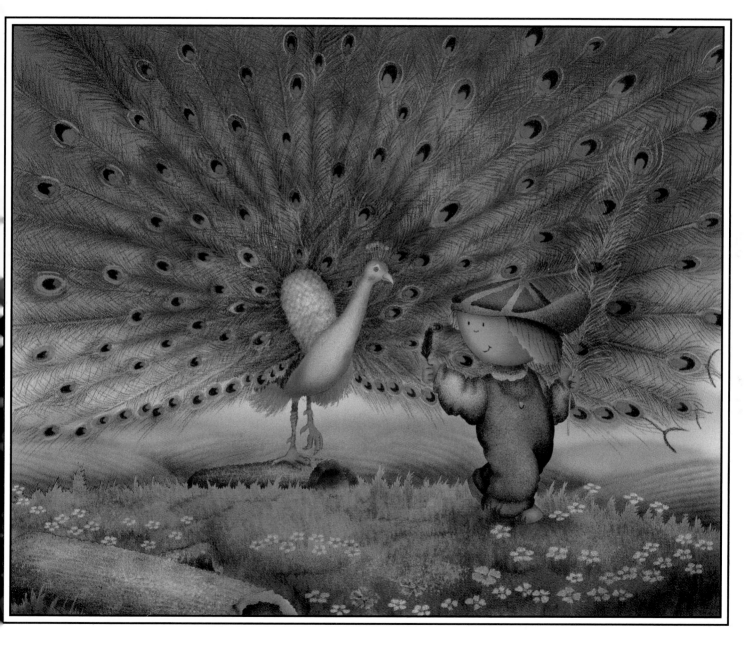

I ask a Magician to show me some magic.

"Can you bring back the bird
who has lost this red feather?"

He waves his big arms. "I cannot do that.
Only very white doves come out of my hat."

Then he gives me a feather and wishes me luck.

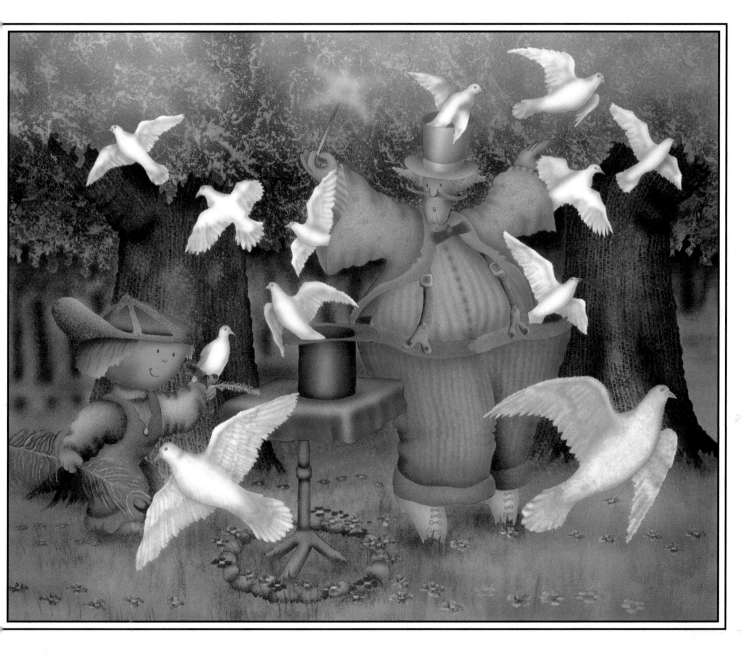

The mountain is high and Marlene comes with me.

An Eagle flies down to ask why we are there.
"We want the red bird who lost this red feather."

"Red birds don't fly this high in the sky.
No red feathers here," he says, and bends down
to give us a feather that's a very nice brown.

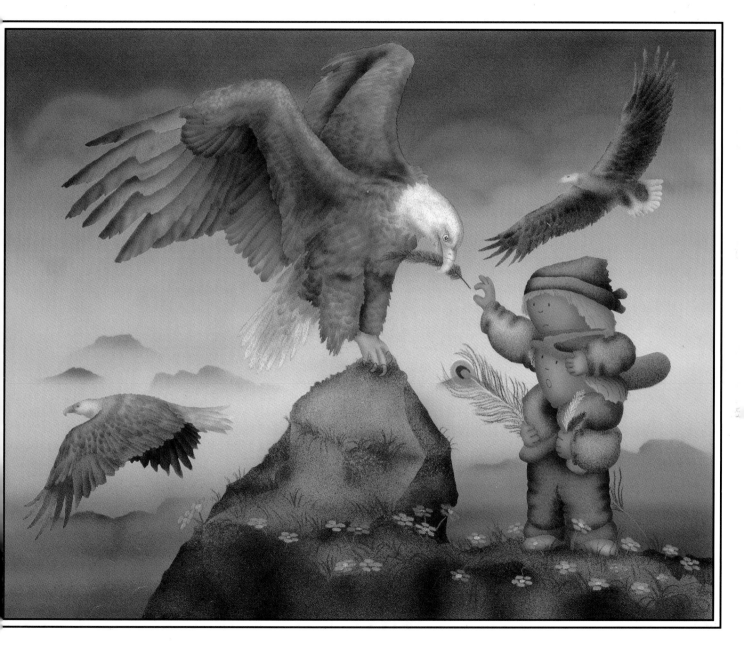

We ride down the cliffs to the edge of the sea.
We call to the gulls and they fly close to me.

"Not ours," say the gulls. "Our feathers are gray."
They add one to the others and we go on our way.

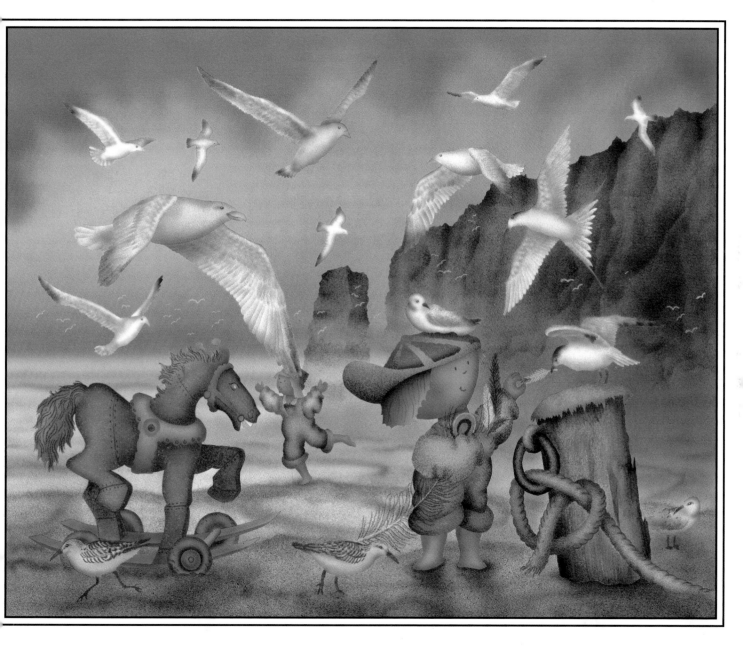

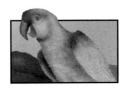

A Pirate has come from lands that are far.
He says he can't take us to where red birds are.

"My boat is a wreck, I'm tired and old.
I'm looking for someplace to bury my gold.

"That feather," he says, "is from no bird I've seen
Have one from my parrot. It's a very bright green."

We give up the search. The red bird can't be found.

Going home through the woods, I see on the ground
a red cardinal crying and hopping around.

"I've got your lost feather. There's no need to cry."

But the red bird says sadly: "It won't help, I can't fly.
I need more than a feather. I've broken my wing.
I'm so hurt and so hungry, I can't even sing."

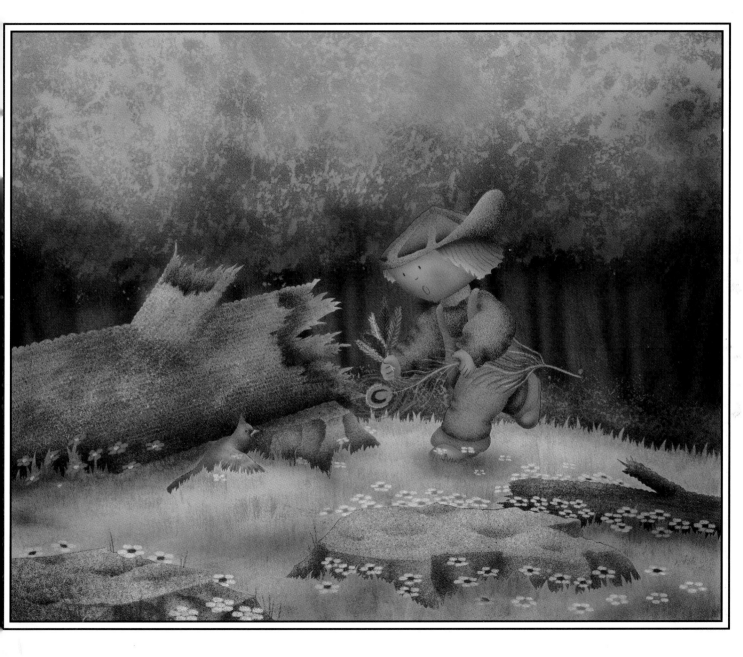

I ask Marlene to help and we work hard together,
We build a bird's nest and put in every feather.

We feed him and nurse him until he can fly.

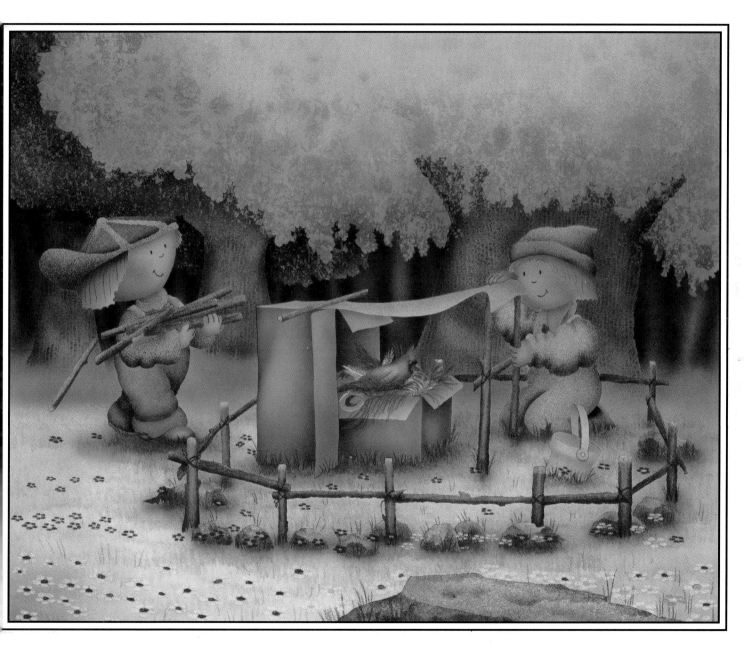

Then we call all our friends to wave him good-bye.

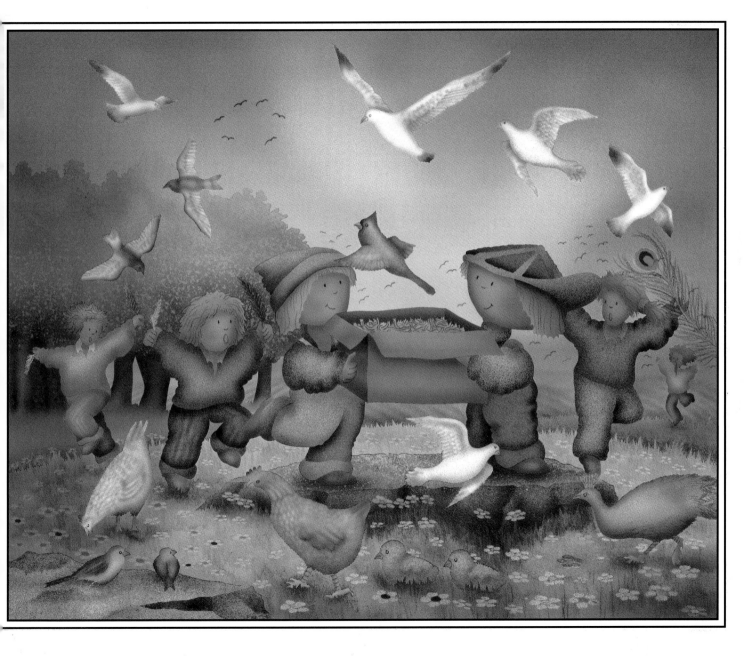

For Manon

© 1994, Gilles Tibo

Published in Canada by Tundra Books, 481 University Ave., Toronto, Ontario M5G 2E9

Published in the United States by Tundra Books of Northern New York, Plattsburgh, N.Y. 12901

Library of Congress Catalog Number: 96-62005

Canadian Cataloguing in Publication Data
Tibo, Gilles, 1951–
[Simon et la plume perdue. English]
 Simon finds a feather

Translation of: Simon et la plume perdue.
ISBN 0-88776-402-9

 I. Title. II. Title: Simon et la plume perdue. English.

PS8589.I26S528513 1997 jC843'.54 C97-930055-X
PZ7.T52si 1997

[Issued also in French under title: *Simon et la plume perdue* ISBN 0-88776-403-7]

Tundra Books acknowledges the financial assistance of the Canada Council.

Printed in Hong Kong by South China Printing Co. Ltd.

01 00 99 98 97 5 4 3 2 1